PERSONALS

CALL NOW!

PERS

Portraits o

and Their

CALL NO

ONALS

REAL People
Personal Ads!

UNIVERSE

Women Seek
1-800

DESIGN:
Paul Kepple and
Timothy Crawford
@ Headcase Design

First published in the United States
of America in 2000
by UNIVERSE PUBLISHING
A Division of Rizzoli International
Publications, Inc.
300 Park Avenue South
New York, NY 10010

Library of Congress Card Number:
00-107481

2001 2002 2003 2004 2005 2006
10 9 8 7 6 5 4 3 2 1

ISBN: 0-7893-0523-2

Printed in Singapore

ACKNOWLEDGMENTS

The author would like to give special thanks to all those who contributed to the making
of the photographs in this book:

COPRODUCER
Liza Hayes

PHOTO ASSISTANTS
Michael Burke pp. 14–15, 16, 21, 32, 36, 58, 78, 79, 86, 93, 96, 101.
Lorraine Day pp. 12, 22–23, 26–27, 63, 80, 90–91.
Tim Dolan pp. 12, 50–51, 108.
Doyle Leeding pp. 11, 17, 18, 28, 30, 31, 35, 38, 39, 42–43, 46, 49, 53, 54, 60–61, 64, 67, 68,
70–71, 74–75, 76, 78, 79, 82, 83, 94, 99, 100, 102–3, 106–7, 111.

HAIR AND MAKEUP
Glenn Alfonso pp. 16, 22–23, 96.
Lady Caviar pp. 42–43.
Ginger Damon pp. 11, 18, 31, 35, 36, 38, 46, 49, 54, 60–61, 64, 67, 68, 70–71, 74–75, 76, 78, 79,
82, 83, 90–91, 93, 99, 102–3.
Suzie Fitzgerald pp. 17, 111.
Chip Swalley pp. 14–15, 28, 32, 86.

STYLISTS
Carl George pp. 90–91.
Gamila for all other photos.
Gamila's assistant: Katie Sances.

WARDROBE
Warner Bros. Wardrobe Department

LOCATIONS
Bandini Truck Stop, Los Angeles. pp. 74–75.
Book Soup, Los Angeles. p. 36.
Chinatown, Los Angeles. p. 79.
CIA (California Institute of Abnormal Arts). p. 30.
Coconut Teaszer, Hollywood. p. 78.
Dry Gulch Ranch. p. 44.
Ed DeBevics, Los Angeles. p. 80.
Edwards Drive–In Theatre, Azuza. pp. 102–3.
Golf & Stuff, Los Angeles. p. 93.
Hancock Memorial Museum/USC. p. 49.
Hollywood Forever Cemetery, Los Angeles/Toni Maier–On Location, Inc. p. 64.
Hollywood Lanes, Hollywood. p. 52.
The Improv, Los Angeles. p. 78.
The Long Beach Aquarium. p. 30.
Michael Childers Studio, Los Angeles. pp. 32, 86.
Monster truck owned by Rick Swanson. p. 39.
The Oviatt Building Penthouse, Los Angeles. pp. 38, 60–61.
Paolina Boxing Ring, Los Angeles. p. 11.
Paramount Studio, Los Angeles. p. 70.
The Park Plaza Hotel, Los Angeles. pp. 54, 76, 83.
Perino's Restaurant. Los Angeles. pp. 90–91.
The Queen Mary Bar, Studio City. pp. 26–27.
Ralphs Grocery Company, Beverly Hills. p. 22.
Schaefer Ambulance, Valley Pres. Hospital, Van Nuys. p. 18.
Star Strip Club, Los Angeles. p. 111.
St. Vincent's Church, Los Angeles. p. 63.
Sunset Beachwood Riding Stables, Los Angeles. p. 39.
Universal Studios Backlot, Los Angeles. p. 46.
Warner Bros. Back Lot, Burbank. pp. 21, 42–43, 96.

PREFACE

by Michael C. Smith

W HEN PEOPLE ASK ME HOW I CAME UP WITH THE IDEA
for *Personals*, I'm not quite sure how to respond. Although I've always
been drawn to personal ads and could never resist reading them, I had never actu-
ally answered one until I began research for this book. Maybe the project was
really just an excuse to let me finally satisfy my curiosity about the people behind
the personals.

I had no idea what I was in for. I was touched, shocked, titillated, saddened,
amused, horrified—but always fascinated—by the people who had placed the
ads. Though, after two years of phone calls, I have to admit that the people I met
and the stories I learned about made for some unforgettable life experiences.

There were hundreds of unreturned calls, late-night breathers, no-shows, hus-
tlers of one sort or another, and people who hung up on me because they thought
I was a pervert looking to fulfill some photo-based fantasy. Of the people I shot,
one had been placing the same ad for ten years with no results, another had gone
on over a hundred dates in one year, and yet another had twenty-two ads running
at the same time! Some even refused to participate unless I could get them dates.

In the end, some of my subjects decided against being included in the book. I
believe the degree of intimacy and eccentricity that they had expressed in their
ads led them to have second thoughts. But those who did agree to be included
make for an awesome group of characters. I hope that the curiosity that led me
to begin *Personals* has culminated in a group of portraits tempered by both
pathos and joy just like the people I met.

SOME WORDS ABOUT THE AUTHOR

"Michael had such a passion for photography. . . . His love of people and zest for life is really exemplified in this intriguing body of work. He has brought to life the ironic fantasies of so many unusual characters. . . . Years ago, Michael took one of my photography workshops. He perservered throughout the week and at week's end, some of my favorite images were those captured by him. Congratulations!"

—GREG GORMAN

"I am an avid collector of photography and am proud to have some of Michael's work in my collection. Michael's enthusiasm and his understanding of subject matter were made even more special by his illness. His photographs have a sense of soul and peace and are to my mind as special as Michael was himself. This is a tragic loss for me, not just as an artist but as a dear and cherished friend. With this book I can now have even more beautiful memories of him."

—ELTON JOHN

"Michael was a friend of mine—a very sweet and talented man. He radiated an enthusiasm for his work and especially for his friends, never dropping a beat. His indomitable spirit always rose to the occasion. His boyish charm, quick wit, and endearing smile made me feel welcome. He was truly a great guy. I will miss him."

—HERB RITTS

"Michael was a sunshine in my life. We worked together for five years and had the best time. He loved life and lived it fully. He had a great eye, a great smile, and a great heart. This book has it all."

—DIANE VON FURSTENBERG

FOREWORD

by Bruce Vilanch

OF COURSE, WE'RE NOT THE KIND of people who would take out personal ads. You and I. After having been an object of desire for so many years, the idea of actually picking up a pen and seeking some action is as remote to me as snow on South Beach. I mean the kind that falls from the sky. And you, well, if you have enough time on your hands to read this foreword, as well as enough strength in them to actually lift the book off the coffee table, you're certainly well beyond a classified affair. People who take personal ads can't even manage that, or so I thought until I started looking through my late, great friend Michael's collection of portraits of ad-takers.

Michael was something of an ad-taker himself—not ads like these (although who knows what people really do under cover of darkness?)—but big, splashy ads for big, splashy movies. He ran an ad department for a major Hollywood studio in the last quarter of the last century, the quarter in which the ad was frequently acknowledged to be more interesting, more artistic, and more memorable than the movie. Michael saw the beauty in advertising, as this book clearly demonstrates. Selling the Batman movies and selling your own personal desire to be Sandra Dee are equally challenging artistic endeavors.

This book chronicles dozens of individuals in their quests to sell themselves to other individuals, sometimes for an encounter, sometimes for a lifetime. Having safely placed their ads, they await a nibble. And here comes Michael to take them to the next level. In each portrait, he allows the ad-takers to portray the fantasy version of themselves that they're selling. Even the Home Shopping Network hasn't figured out how to do that yet. The result—people allowing themselves to be what their ads claim them to be—is enthralling. It's the kind of role-playing the Royal Shakespeare Company has yet to encounter.

A word of caution: if you've never read an authentic ad from the personals column, you may need a beverage of some potency within reach during your voyage of exploration. You're entering the last refuge of the romantic, one stop shy of the slippery railing of a high bridge. The search for true love is no trek for sissies. It's dangerous and outrageous and fraught with hitherto unimaginable sights. But if you've ever wondered what people would look like if they really let it all hang out, look no further. You've found the joint.

CHART OF ABBREVIATIONS

BiWM	*bisexual white male*		**N/S**	*nonsmoking*
bl/bl	*blond hair and blue eyes*		**N/S/D**	*no smoking or drugs*
br/bl	*brown hair and blue eyes*		**SBF**	*single black female*
br/br	*brown hair and brown eyes*		**SBM**	*single black male*
br/hz	*brown hair and hazel eyes*		**SKS**	*seeks*
D&D	*drug and disease free*		**SPRM**	*single Puerto Rican male*
DJM	*divorced Jewish male*		**SWF**	*single white female*
DGM	*divorced gay man*		**SWHF**	*single white Hispanic female*
GBM	*gay black male*		**TV**	*transvestite*
GWM	*gay white male*		**UR**	*you are*
ISO	*in search of*		**VGL**	*very good-looking*
LTR	*long-term relationship*		**W/AF**	*white or Asian female*
masc	*masculine*		**W/S**	*water sports*
MC	*married couple*		**WTD**	*wanted*
MWC	*married white couple*		**YO**	*years old*

and rollerblading. Sophistication a must.

6',

1e).

d 2

HER

ven

am

but

ic!

y &

or

k

BISEXUAL TRANSSEXUAL POWER-LIFTER

Domina, and all around computer geek. I also wrestle. I'm a fair athlete. Looking for someone to obey me. I'm terribly overworked and need fun. PLEASE DON'T BE BORING. Call Box #75617. ☎

TON O SEEKS

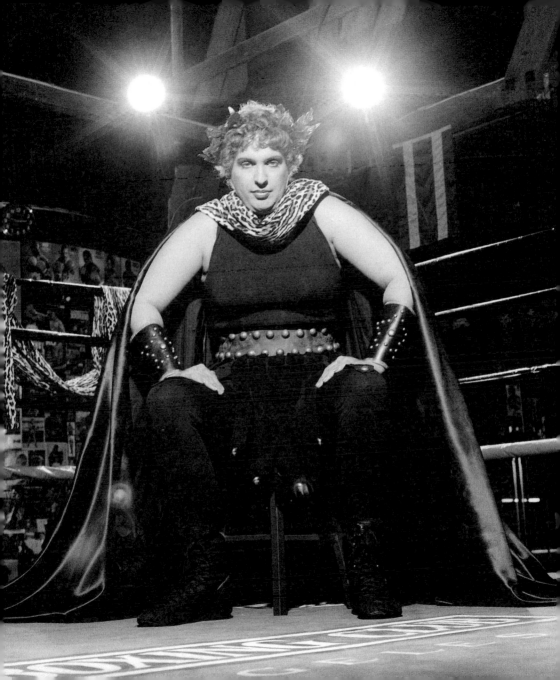

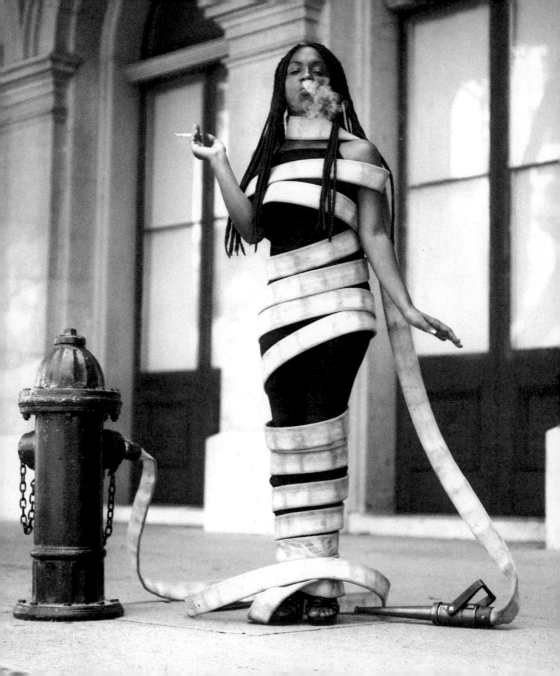

always approved. Call Box #85547. ☎

START A FIRE IN MY HEART

Very attractive SBF, 22, 5'1", 105 lbs., seeking very attractive, sexy firefighter, 25–32. If you love movies, music, and having fun, then you are the one for me. Race open. Call Box #14328. ☎

TALKIN' STARS

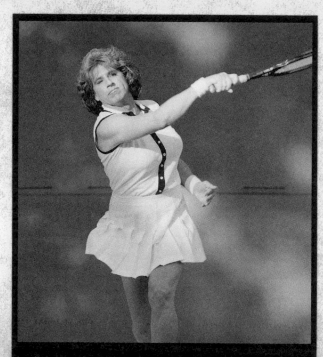

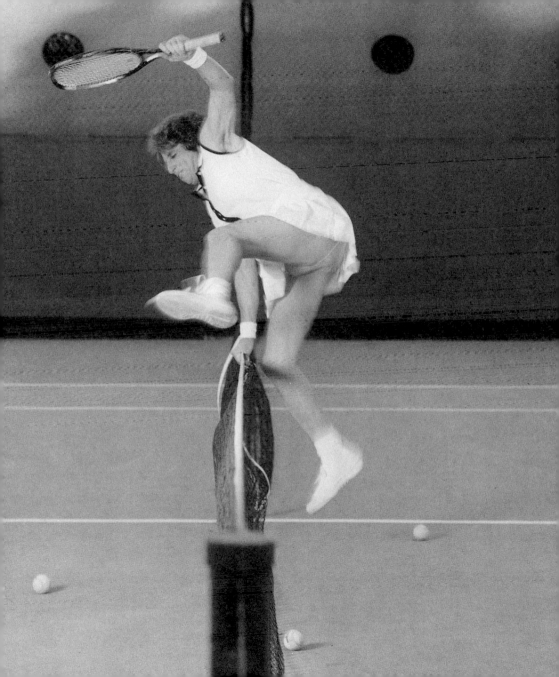

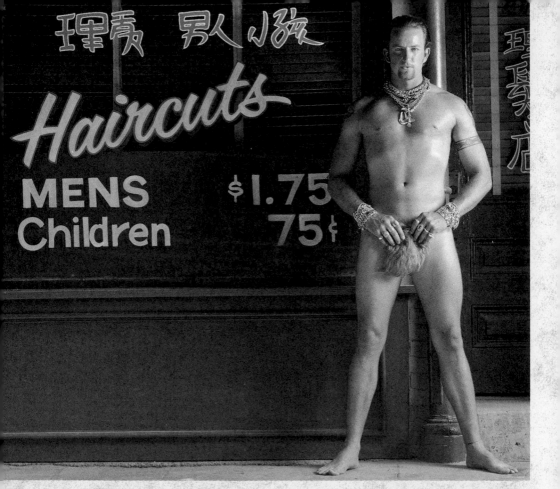

DO YOU HAVE A HAIRPIECE?

*Oops. Do you have herpes? SWM, 26, 6'1", blond/blue, model type. Silly, stylish, into everything but these ads, looking for the same. Life is much easier with a lover. Call Box #62317. ☏

I-DREAM-OF-JEANNIE LOOKS,

5'6", 125 lbs., blonde, very athletic/curvaceous body, considered a 10 inside & out, 30s. Interior designer, loves sports. Intelligent, sexy, confident, outgoing, fun-loving, sweet & sassy lady, great personality, sense of humor, seeking extremely good-looking, well-built, sexy, tall WM, similar characteristics. Call Box #78282. ☎

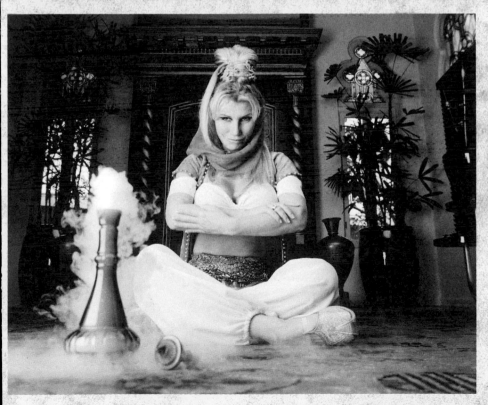

DARLING !

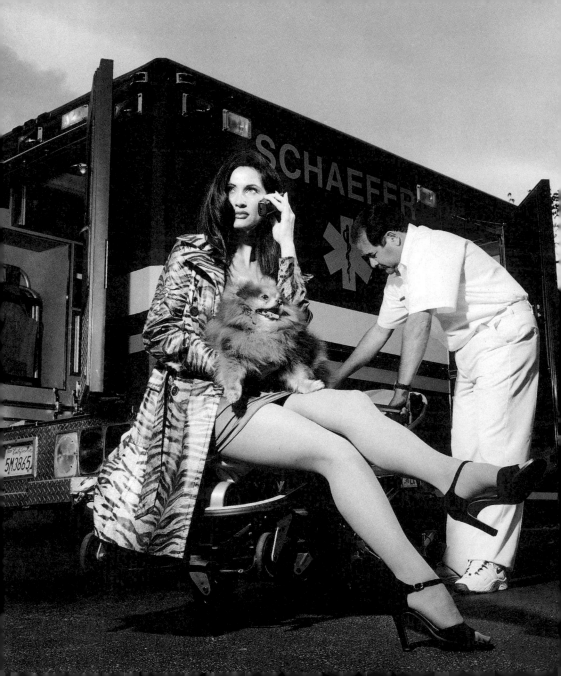

911 KNOCKOUT BRUNETTE

calls for sensual CPR/dynamic LTR. Me: dangerous beauty with mystical doggie in tow. You: strong ability to withstand potential cardiac arrest and little objection to the sound of screeching brakes . . . phone home. Call Box #33774. ☎

UNDERWEAR MODEL

lives near me. Tall, attractive, funny, easygoing, 30, SWM seeks thin, intelligent, creative female with a good sense of humor and love for animals. Call Box #96336. ☎

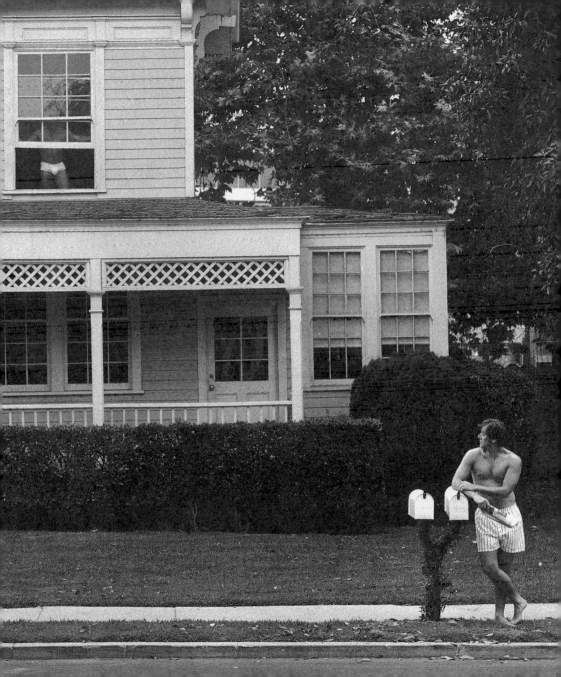

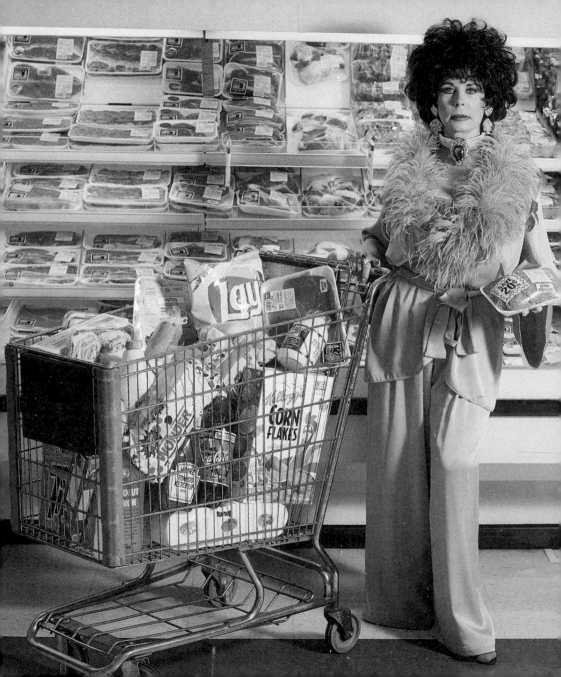

ou up!"

e Few"

ays

Y

ssue
naster
WN
ahlan

rk

Y

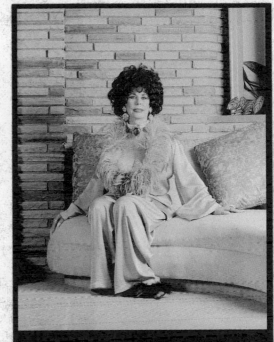

ELIZABETH TAYLOR CLONE,

but svelte and younger, classy, volup-
tuous, knockout lady with morals, needs
a mature, very financially secure gen-
tleman for a committed and loving rela-
tionship. N/S. Call Box #89451. ☎

B

Re
P
L

HOT

Elite Ladies

lover of music, movies, magic

FULL M

Ex—male stripper, 40, c

HOT Italian angel bab

lifetime adventure! Ca

DADLING

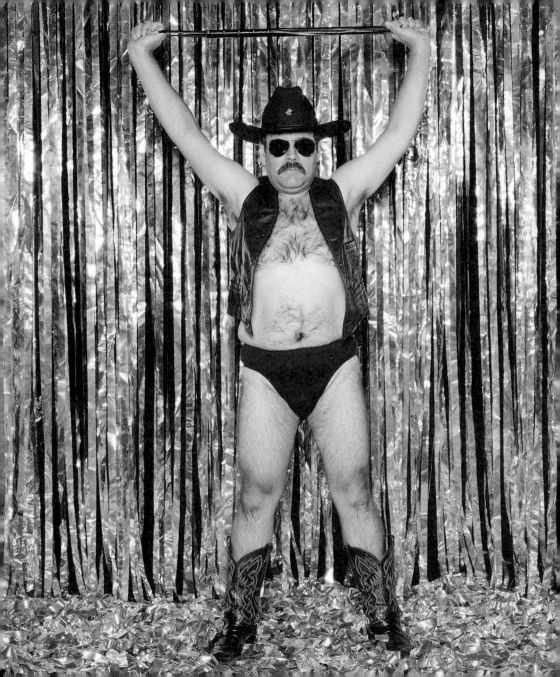

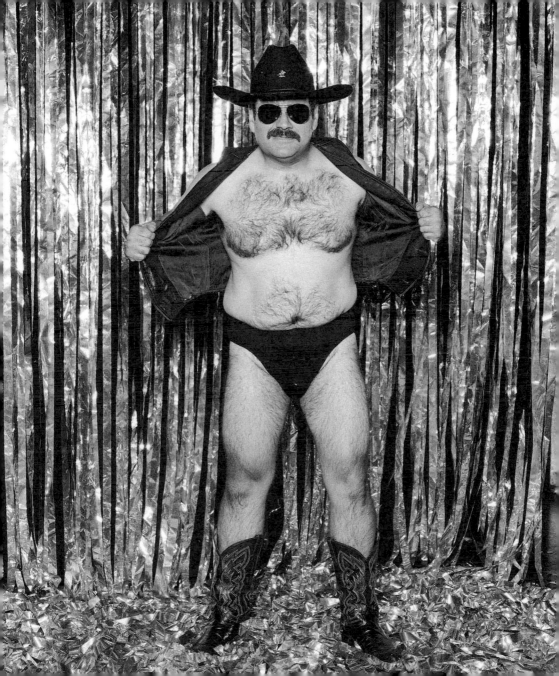

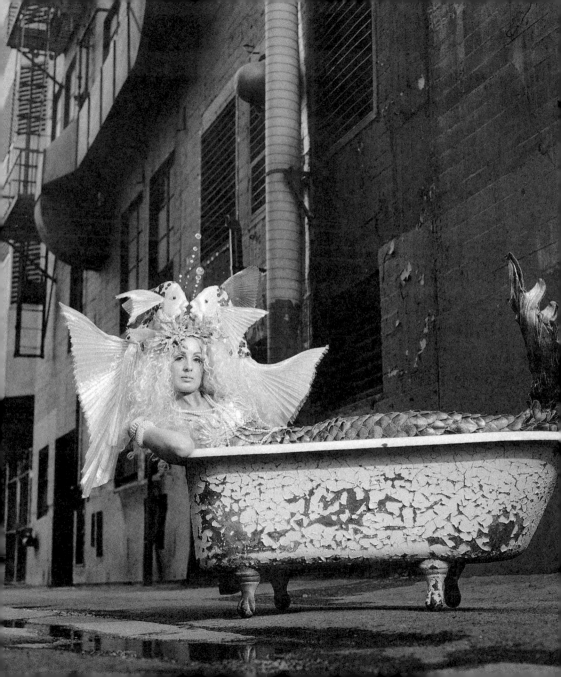

Ladies, You Can Do It!

URBAN
MERMAID

SWF, 28, 5'10", 140 lbs., wishes to lure Neptune SWM, 30–40, 6'+ for languid baths and salt rubs. Must be physically fit and financially secure. Join me for seafood. You bring the mussels/NO CRABS. Call Box #35731. ☎

 The Johnson Agency's

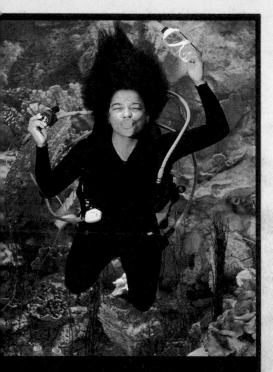

EASTERN THINKING DIVA

SF, 30, 5'6", 130 lbs., scuba diver, brown/ brown, very active, into rollerblading & surfing, seeks SF, 25–35, who's sporty, healthy, vegetarian, into diving, surfing, & weight training. Be feminine, no butches! Call Box #57896. ☎

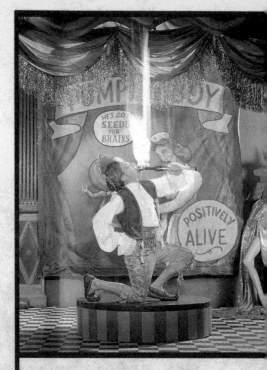

FIRE EATING WITH THESE LIPS

bull whips, & a well-versed hand at poker. Allow this magician, 28, 5'8", 145 lbs., w/ brown/hazel eyes, to pull rabbits out of your B-cup. You be 22–25, happy, ener- getic, hot redhead with pale skin. Call Box #77704. ☎

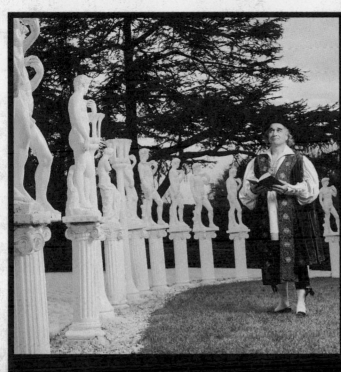

RECIPROCAL ENTHRALLMENT

Sexy Harvard philosopher, renaissance man, mega-brained Brando, DJM, 56, principled, perceptive, powerful, playful, athletic, attentive, ironic, irreverent, irenic, prowling for one gloriously gorgeous gambler, grabbing my body & belngm, igniting my absurd adoration perduringly. Age/race whatever. Call Box #14001. ☎

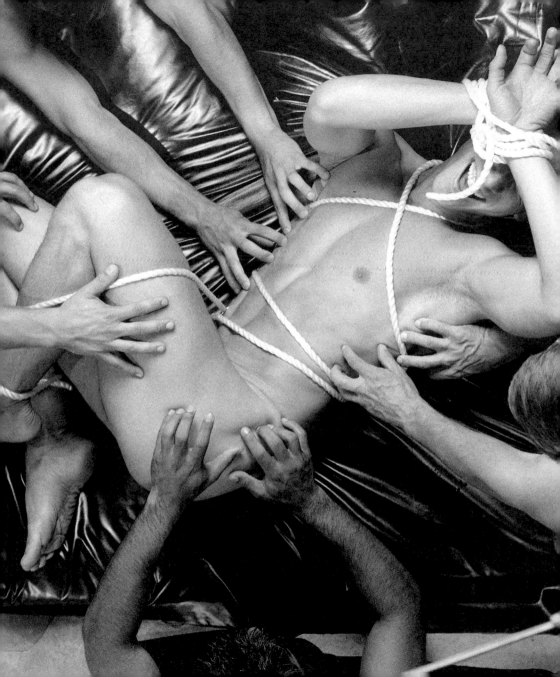

TICKLE PARTY GUY

Very good-looking WM 33, 6', 175 lbs., br/br masc in-shape available for tickle parties. Have been tied up & tickled by groups of guys & can't get enough. You must be normal, look, sound & act masculine. DISCREET ONLY. Call Box #86511. ☎

CORPORATE DARE-DEVIL

seeks mechanic into stocks & bondage for fun, fast times and trucker fantasies. I am a good-looking GWM, 40, European. Call Box #88991. ☎

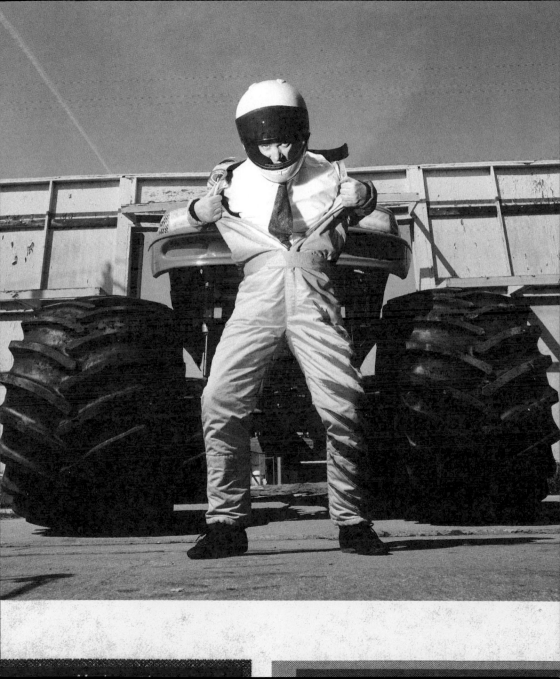

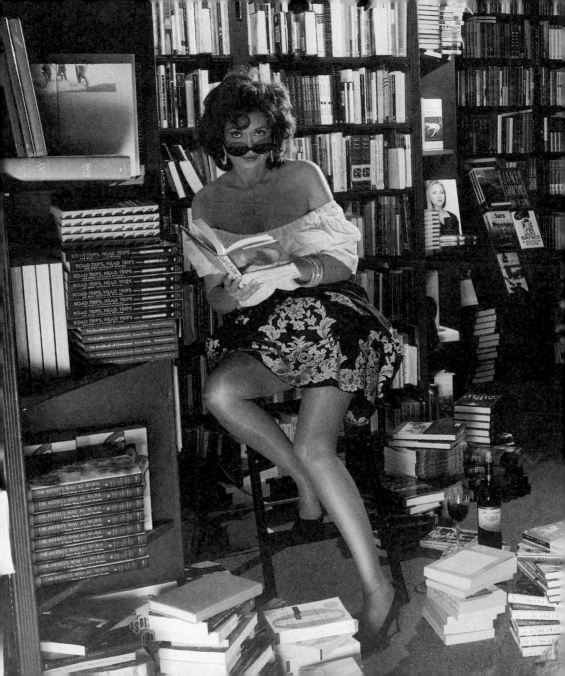

SOPHIA LOREN +Ph.D.

Earthplane men: I bring so much to the table, I want it buffet style. Think lavish. Evolved men: if God carries a wallet, he has my picture in it. Sanctified woman. Call Box #12475. ☎

Powerf
physica
connec
spiritua
explore
Psycho
healthy
& at pe
be & e
sees th
ordinar
radiant
light. A

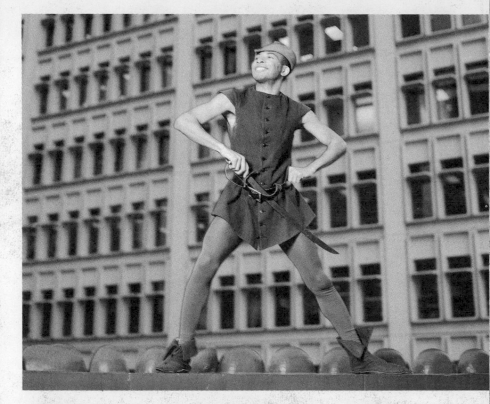

AFRICAN AMERICAN PETER PAN

TONTO SEEKS LONE RANGER

New in town, dark & handsome, Native American GM, 32, 6'2", 200 lbs., witty, who dances and goes to clubs, seeks masculine GWM, 21–35, open, to escort you into the finer side of life. You must love yourself. Call Box #36217. ☎

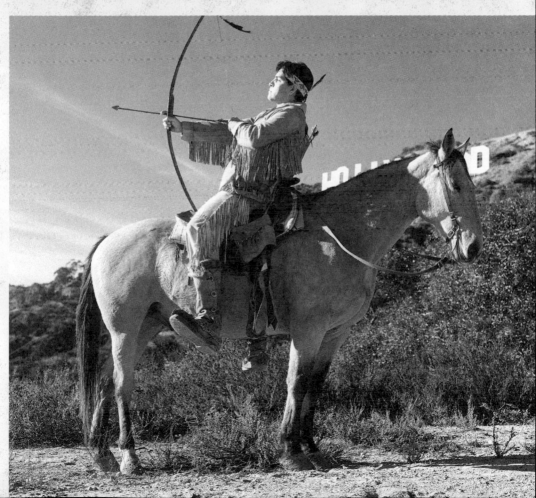

prefered, no back hair. Ca

TRANNIE

41-year-old biker rocker c

legal, f to m Bad Boy for kin

Box #65288. ☎

CHASER.

ick Baby Doll, seeks barely

y sex. Call Box #28291. ☎

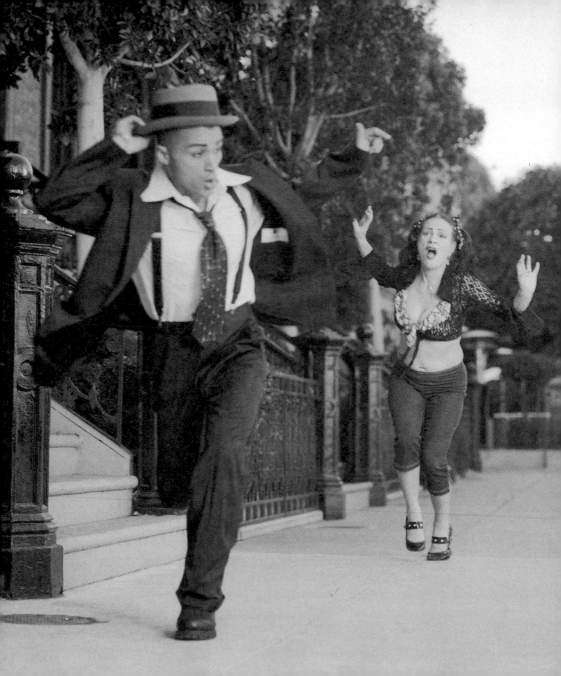

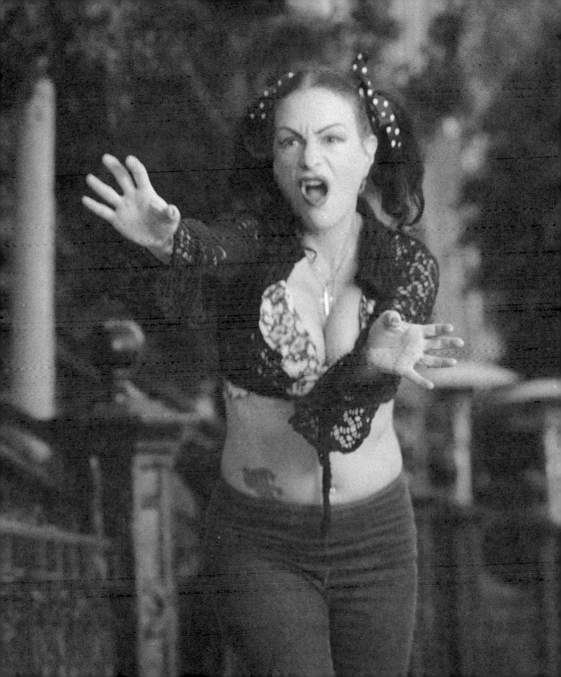

PLACING YOUR AD

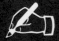

1) CHOOSE YOUR CATEGORY:
- ❏ Women Seeking Men
- ❏ Men Seeking Women
- ❏ Men Seeking Men
- ❏ Women Seeking Women
- ❏ Anything Goes
- ❏ Multiple Partners
- ❏ Transgender
- ❏ Pen Pals
- ❏ Passing Trains
- ❏ Activity Partners
- ❏ Alternative Lifestyles

2) TELL US ABOUT YOURSELF.
Age _____
Marital Status _____
Height _____
Weight _____
Body Type _____
Ethnicity _____
Religion _____
Astrological sign _____
Education level _____
Profession _____
Pets _____
Children _____
Piercings/Tattoos _____
Favorite Activities _____
Smoking _____
Drinking _____
Drugs _____

3) WHAT ARE YOU LOOKING FOR? (SELECT ALL THAT APPLY.)
- ❏ Relationship
- ❏ Long-Term Relationship
- ❏ Sex
- ❏ Friendship
- ❏ Support
- ❏ Whatever
- ❏ Something Online
- ❏ No Answer

4) CAN YOU DESCRIBE YOUR IDEAL MATE:
Age _____
Marital Status _____
Body Type _____
Ethnicity _____
Religion _____
Astrological sign _____
Education level _____
Pets _____
Children _____
Piercings/Tattoos _____
Favorite Activities _____
Smoking _____
Drinking _____
Drugs _____

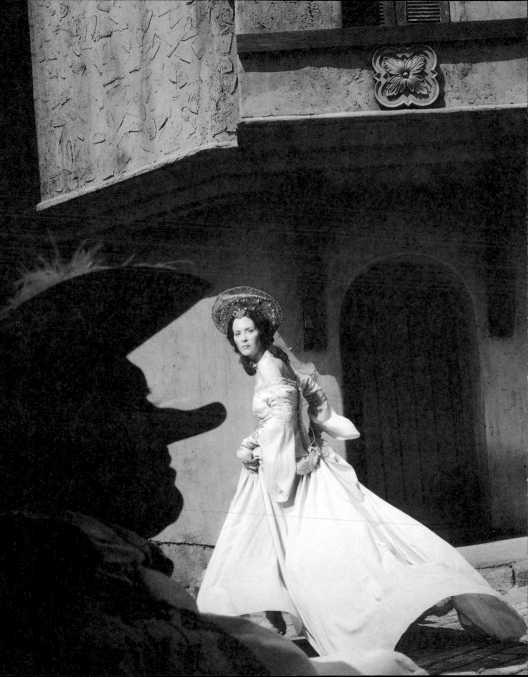

ROXANNE SEEKS HIP CYRANO

Hip Sandra Bullock type, 30s, works in film. Seeks fab, creative, funny guy, in shape, extra points if really cute. Call Box #52876. ☎

BUTTER

-FEET

CECILIA BARTOLI LOOK-ALIKE WANTED

Writer, SWM, 29, seeks SW/HF, 20–31, with big, wide, womanly body, lively, beautiful face and eyes, loyal heart, traditional values, funny, intelligent, loves animals, classical music. N/s/d, no kids, lawyers, Libertarians, flakes, dreaded diseases. Call Box #49652. ☎

Call Any Time
1-999-524-6554

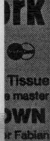

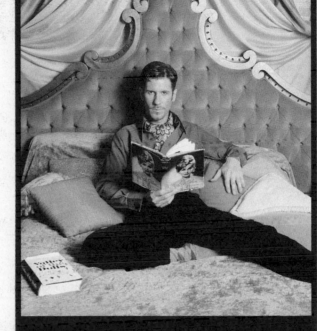

DARLING I LOVE YOU BUT GIVE ME PARK AVENUE

GWM, 34. My passions: Flea markets, 60s suburban culture, Pedro Almodovar. Wants: Romance, brains, integrity. Needs: LTR with committed 32–45, cool guy. Latin or similar Adonis a +. Call Box #69856. ☎

no tight jeans. Call Box #54445. ☎

BOWL YOU OVER

WITH MY HUGE COCK. SM, 27, 175 lbs., br/br, looking for a hard-bodied, nonsnoring man, 25–40, with big arms and no cats. I'm into bowling, theater, and the gym. Let's work out together. Call Box #47391. ☎

NANA AND POP

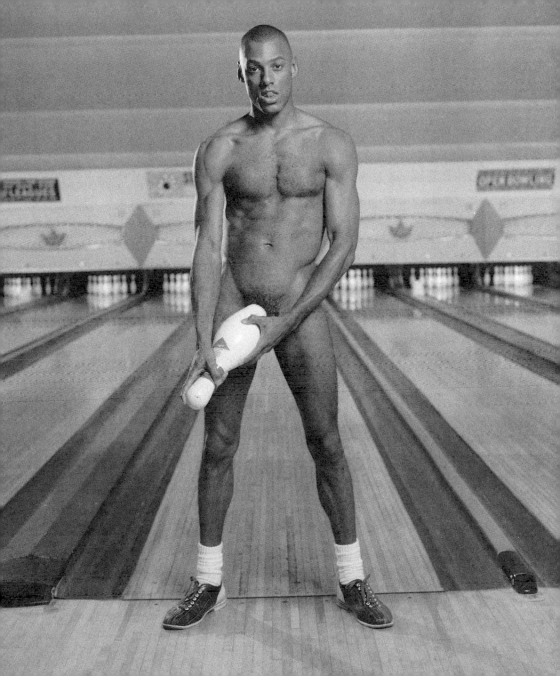

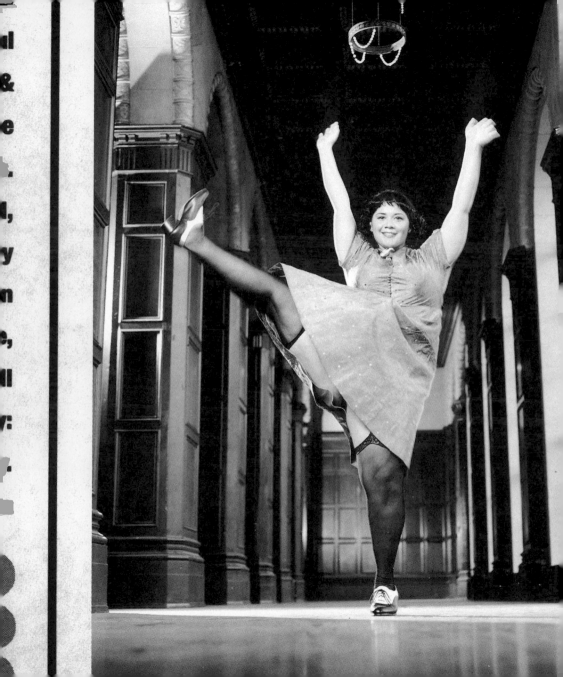

DO YOU LIKE TO LINDY?

Hop that is. SWHF, 25, 5'6", black/brown, curvy cutie, Hollywood area, happily trapped in the 1940s–50s. Seeking a cool, swingin' cat, 21–29. Sideburns, tattoos, and dark hair a plus. Call Box #84752. ☎

HT.

 or
tate

ut,

CH

ne
into

or.

Y?

rvy
he
21-
s.

LET'S CELEBRATE THIS GREAT ADVENTURE OF LIFE! TOGETHER.

I am ready for the "Love of my Life." 51. Committed to a life of love, personal/spiritual development, joy, contribution, peace, health. Seeker, successful professional, yoga teacher, writer, poet. 6', attractive, fit, slim. Hair. Father (none home). Bright (MENSA), advanced degree. Divorced 3 years. WHAT I AM SEEKING IN A PARTNER & RELATIONSHIP: (In what follows, my intention is to be and give the same. I haven't mastered all this, but am working on it. You needn't match 100%, but please be much of it. This is not a checklist, but a seed of possibility, a dream and intention to grow into.) Chemistry! Magic! Powerful mutual attraction, energetically and physically. Passion. Juice. Deep soul connection! Seriously pursuing personal and spiritual growth. Advance seeker, active explorer of Life's potentials and mysteries. Psychologically and spiritually evolved. Healed, healthy, whole, balanced, clear, aware. Happy and at peace with her life and self. Flexible, can be and do whatever is appropriate. Awake, sees through the veil of illusion we call "ordinary reality." Great, high energy: a radiant, glowing presence of love and joy. A light. A lover! Open-hearted, walks and talks in love. Loves and accepts unconditionally, including herself. Can receive my love. Crazy about me, loves and appreciates me and shows it. (And I her.) We believe in, build up, and support each other in mutual growth, healing core issues, success, becoming

all we can be. We are committed to each other's total well-being. We proactively help each other realize our needs, dreams, and true potential self: in the world and spiritually. We bring out the highest and best in each other. Alive, dynamic, lives Life fully, large. Open to all of Life. Celebrates Life, joyful, playful, sense of humor, fun, lots of laughter. Intelligent, interesting, a reader. Affectionate: physically and verbally. Great kisser. Loves lovemaking: passionate, sensual, frequent, spiritual, ecstatic, Tantric Union. Integrity, truth and honesty in everything. Ready to commit, build a life together with the right partner, work through the challenges. Healthy, fit, slim, health-conscious. Vegetarian or close to it. Nonsmoker. Beautiful physically. Honest, open, conscious communication about everything. Fully express feelings. Intimacy, vulnerability.

Ready to go deep together. Trusting, accepting. Real, authentic. Available, has time and energy for great relationship. Does regular spiritual practice such as yoga, meditation, Tantra, Shamanic work, tai chi, breath work, sound work. Strong, accomplished, confident, disciplined, adult, responsible, a leader. Solid sense of priorities, values, and Self. I need a Queen to meet my King. We have our own great lives independently and walk side by side as equal partners sharing them. The relationship usually flows naturally, lovingly, peacefully; not always hard work and conflict. We can teach each and challenge each other, point out old issues/blind spots with love and support. We can receive feedback/ teaching openly/non-defensively. We can agree to disagree, accept and respect the differences. Contributing

Great Adventure continued on next page

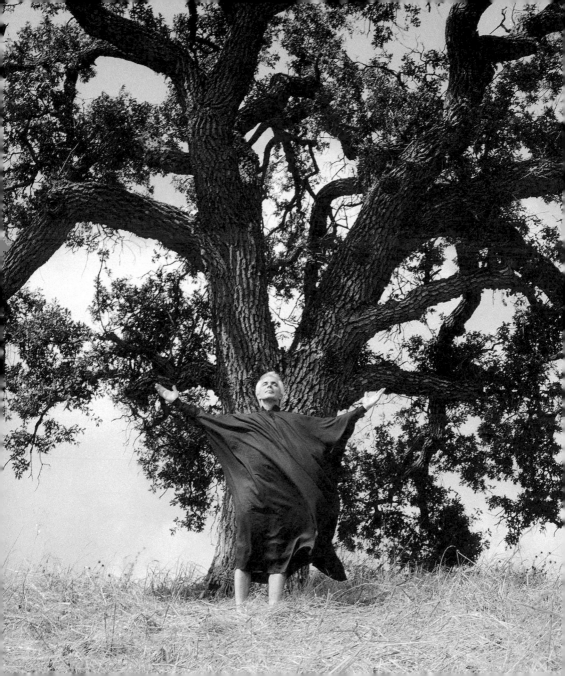

"Great Adventure" continued from previous page

in the world. Lives in gratitude. Lives in the moment: mindful, present, aware, grounded, centered. Kind, warm, respectful, compassionate, giving, sensitive. Attitude of abundance, no lack or limitation. Positive, optimistic. Very feminine, yet balanced in masculine qualities too. She recognizes and lives the Goddess within herself. Juicy, wild, creative, intuitive, free. Done shadow work. Financially secure. Kids or no kids OK. Lover of nature. Socially/environmentally conscious. Lives reasonably close (Santa Monica). Prefer tall, under age 50. Not critical, negative, angry, judgmental, overly perfectionist, controlling, volatile, distant, fearful, rigid, insecure, stressed, worrier, needy. I'm ready for a magnificent, conscious, sacred relationship.

I seek a life partner, best friend, soul mate, lover, and Goddess to share a soulful, open-hearted, intense, growing, intimate, stimulating relationship. I'm ready for a partnership that becomes a beautiful sanctuary/haven we can come back home to together: the "Lover's Garden." I'm ready for mutual love: at its most nurturing and healing, most powerful and mature, most ecstatic and transforming: love at the level of Grace. I'm ready for a relationship where we recognize the God/Goddess in each other (and ourselves), where we live and relate from who we really are: our True Nature. I'm ready for that relationship that will help bring about heaven on earth, here and now. It is time to meet my "Beloved." Namaste. Call Box #27986. ☎

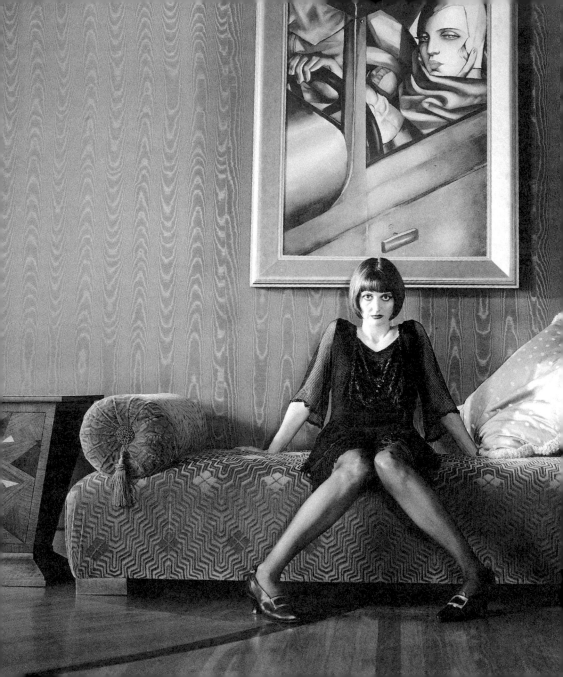

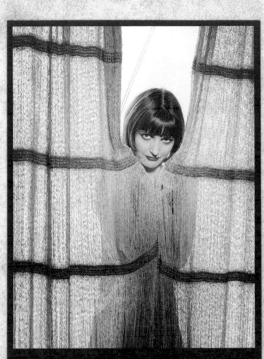

one needs to know. Call Box #99591. ☎

CATHOLIC AS HELL

Bohemian by blood, and Democrat by choice. 33-year-old artist. I'm new in town seeking friendship, coffee, art, and someday, sex after mass w/a like-minded woman. Think Sam Shepard w/out the booze. Call Box #21827. ☎

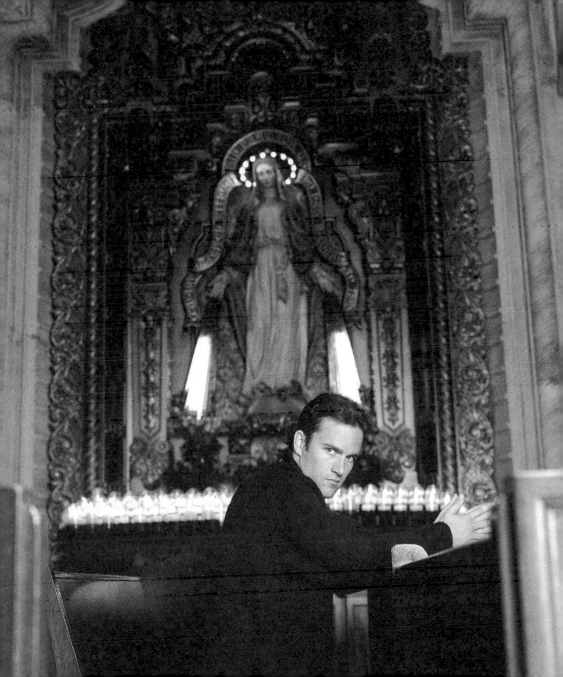

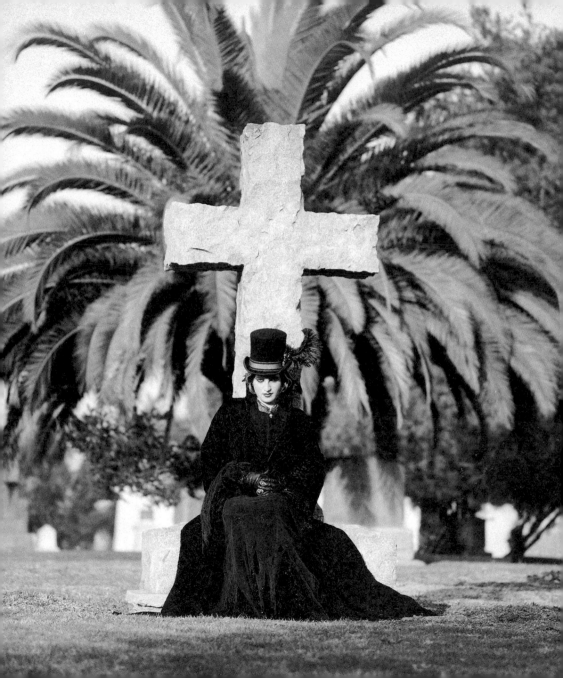

VAMPIRE HUNTRESS.

L.A. is supposed to be the Vampire capital of the world, so why haven't I met any yet? SWF, 22, musician, New York import, seeks interesting male, 21–30, to share the secrets of L.A.'s underground. No drugs, serious only. Call Box #49832. ☎

MR. CANADA 4 MS. AMERICA

Canadian SWM, 30, bodybuilder, seeks an American woman, physically fit & financially secure, for late-night work-outs. I'VE GOT THE GREEN CARD BLUES! Give me a ride and I'll give you a lift. Call Box #46217. ☎

STAR CROSSED

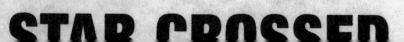

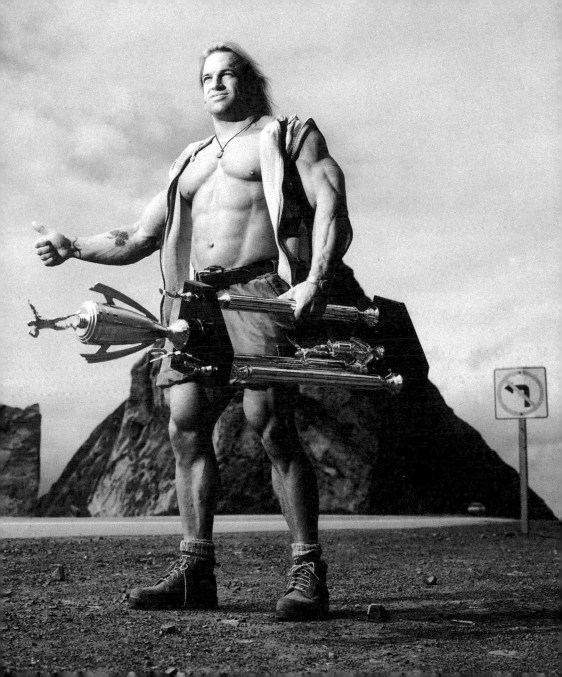

DON'T STOP
WHEN I TELL U

SWF, 27, 5'9", 135 lbs., I'm a mean bitch who'll use sarcasm, wit, avoidance, nastiness, sneers & scorn to make you feel like shit if you cave in to my demands or aren't able to keep up with my brain. Please be a SWM, 28–35, in shape etc. Call Box #62174. ☎

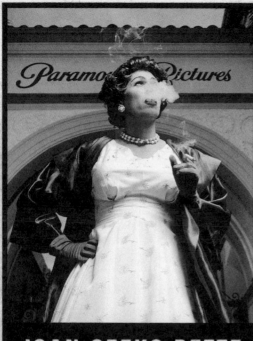

Paramount Pictures

JOAN SEEKS BETTE

Do you have Bette Davis eyes? GWM, slender, quirky, 30ish actor comedian, Crawford connoisseur and otherwise gem of a boy. Seeking possible relationship and Hudson sister frolic with similarly festooned Davis lover. Willing to break into studio gates for you. Let's enjoy some bitch sessions, cocktails, and cigarettes. Blue eyes a plus, but not so bulgy. Call Box #25253. ☎

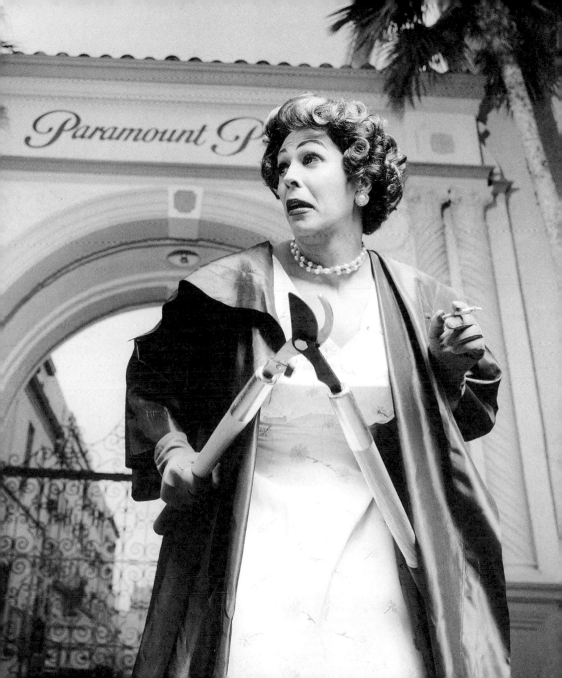

DADDY

seeks the solace of slinky
me dinner at midnight the
empathetic but firm pa
behind a cool, wry exterio

all Box #36342. ☎

BUTCH

but tender femme to serve

n slide into my lap. I'm an

tner whose ardor hides

: Call Box #21765. ☎

WS WINDY

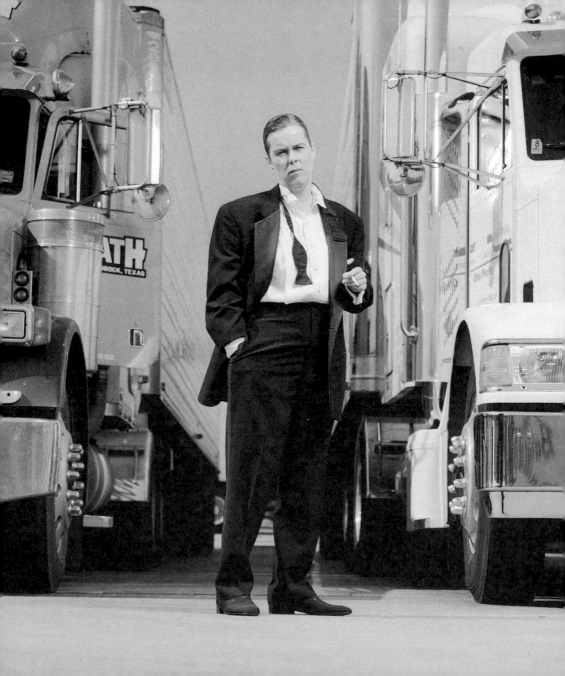

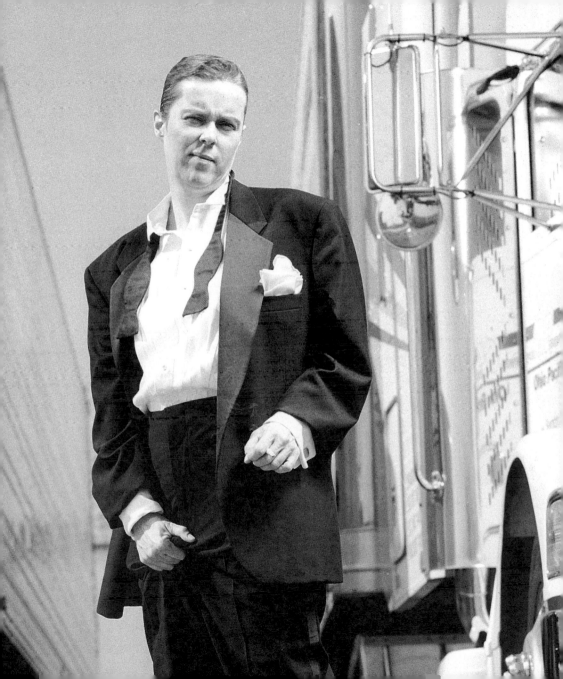

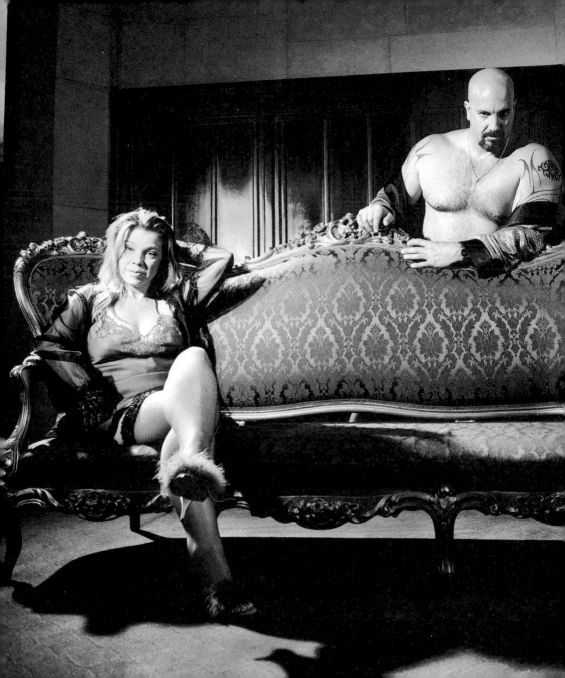

...don't connect [...] hang [...], at least with crunchies. Call Box #45498. ☎

ITALIAN COUPLE

VGL She: Bi-curious, 28, 5'10", 105 lbs., busty and petite. Him: 33, 6'0", 240 lbs., bodybuilder type. Seeking bisexual female, any race, 25–35, fit, busty, for fun, dancing, oral massage, and more. Call Box #56441. ☎

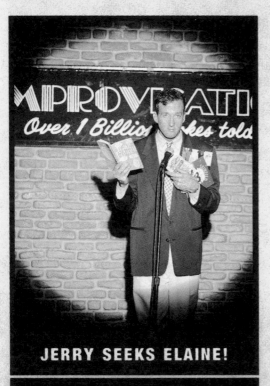
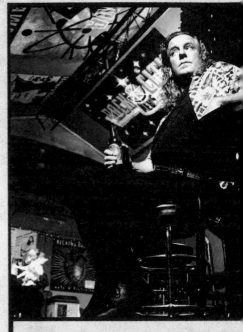

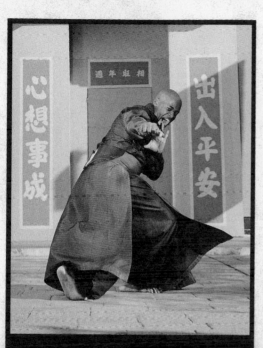

KARATE CHOP THIS HEART

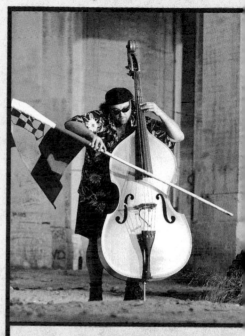

SWAGGERING BASS-PLAY-ING CROATIAN SENSATION

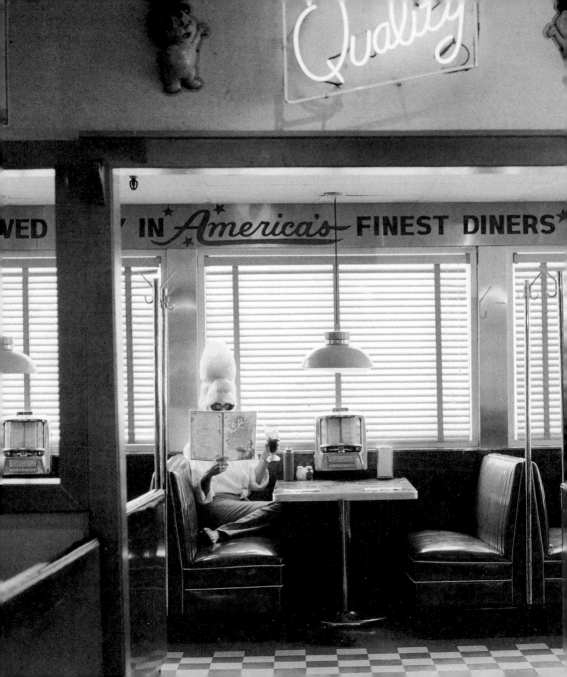

come true!

ROCK TIGRESS

sleek, healthy, happy, 37, no cubs yet, 60s overtones, recovering record collector. Works on some of the worst shows in all TV history. Seeks cerebral, articulate, adventurous, unappreciated W/H barracuda, who treats a woman right. We share interests of live bands, surf music, exquisite dining, offbeat activities, world travel. Call Box #47282. ☎

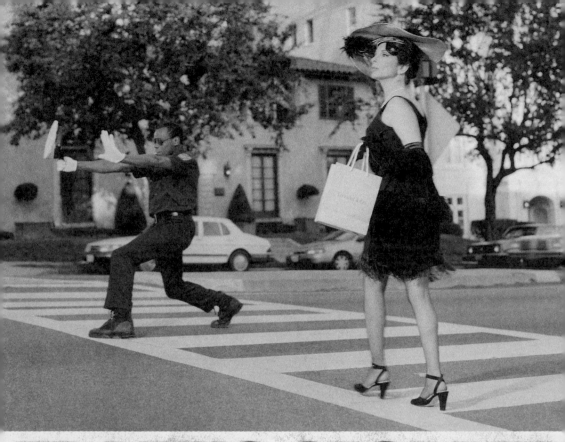

TRAFFIC STOPPER

(Maybe I jaywalk?) Very cool lady. Best features: hair, skin, lips, legs, European looks, pretty brunette, 5'4", 112 lbs., sexy. Good brain/humor, non-religious, seeking SWM, 5'10"+, 37–44 GQ, classically handsome, muscular hard-body with no belly, respect body & mind, compatibility, commitment, successful preferred, great humor a must. Call Box #25896. ☎

LAS VEGAS
TRANSSEXUAL DIVA

Beautiful black pre-op transsexual seeking generous, open-minded men for social activities, dating, and intimate moments. Call Box #52368. ☎

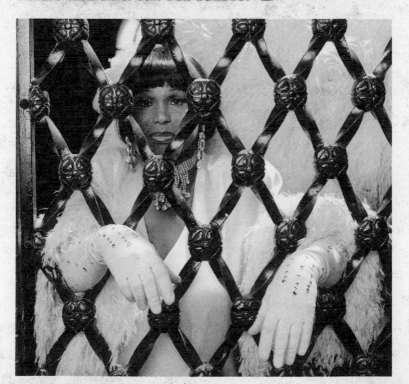

SOME TIPS FOR PERSONALS SAFETY

☑️ Until you meet, try to *stay anonymous*.

☑️ *Listen carefully* for bad signs when speaking for the first time.

☑️ *Don't call unless* you feel completely at ease.

☑️ When going on a first date, *notify a friend* about your whereabouts.

☑️ If possible, *bring a cell phone* programmed with emergency numbers.

☑️ Keep *self-defense items handy*, such as pepper spray or mace.

☑️ Rely on *your own means of transportation* to meet and leave your date.

☑️ *Choose a public place* to meet for the first few dates.

CALL NOW!

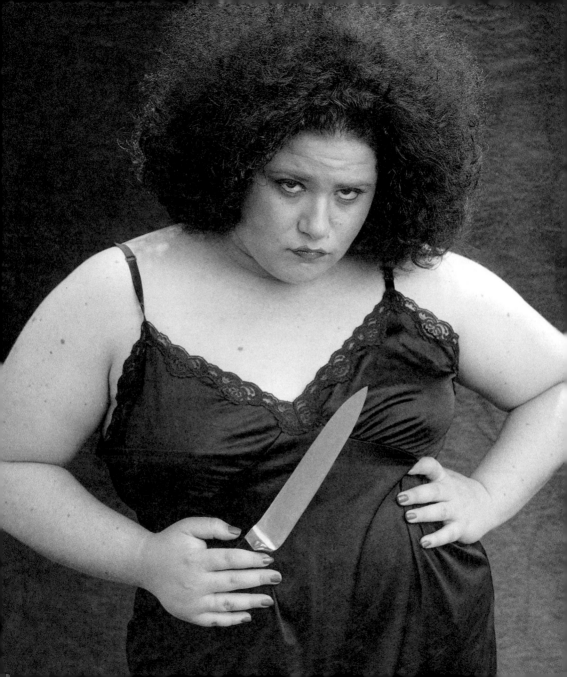

KILLER MOUTH

I'm a SWF, 24, redhead/hazel eyes, full figure, w/ a mouth that can kill. You be a SW/HM, 27–33, 6'+, looks & charm of David Duchovny, professional, outgoing, and good in bed. No slackers, slobs, or IV-drug users. FUNNY IS A BIG-ASS PLUS. Call Box #94200. ☎

UNALTERED H

SWM, theater-degreed, televise

long-term relationship. I'm 47,

childlike build, total bottom, aest

Seeking cosmopolitan, masculine

Bisexual background? Emotiona

Mainstream cultural pursuits,

holistic, metaphysics. N/S/D, HIV-.

ERMAPHRODITE

l author (re androgyny) seeking

'8", 125 lbs., platinum, smooth-

etic nature, provocative wardrobe.

endowed total top SWM, over 48.

y available? Entertainment field?

dining out, weekend getaways,

Call Box #28291. ☎

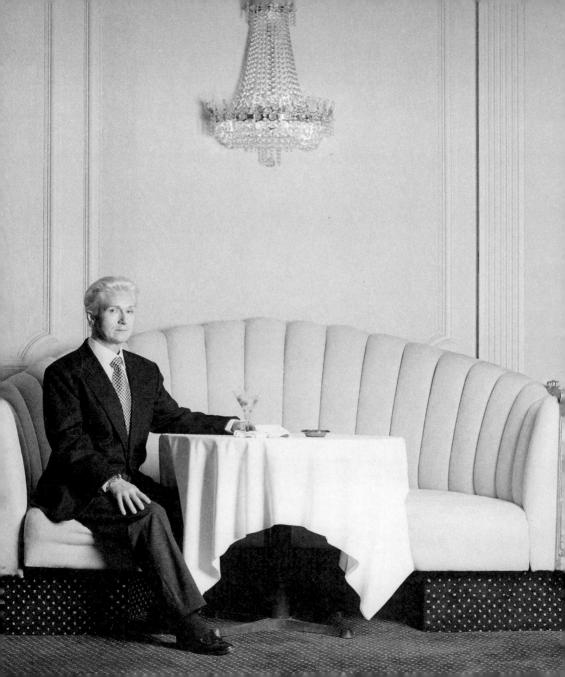

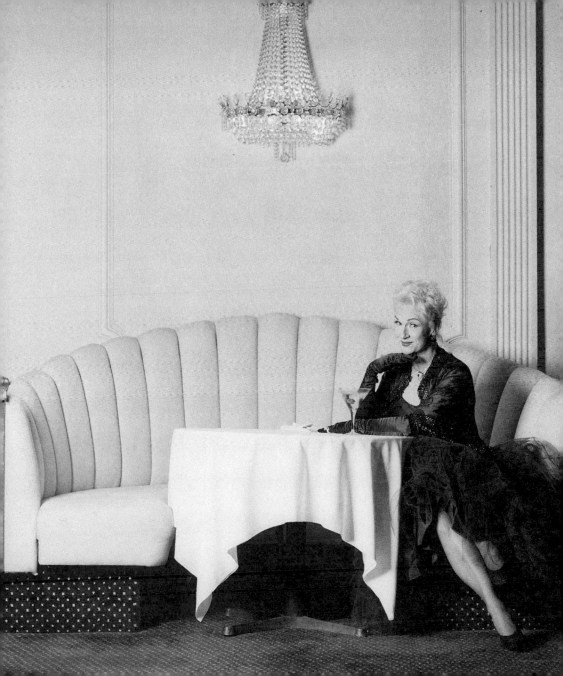

walks along the beach. Call Box #44587. ☎

CINDERELLA

51, waiting for prince. Desires "good man" who has fulfilled himself, wants to appreciate, love, cherish, protect, give to his Cinderella. Me: nice body, pretty face, honest character, loyalty, uncommon, loving, giving heart. Call Box #68745. ☎

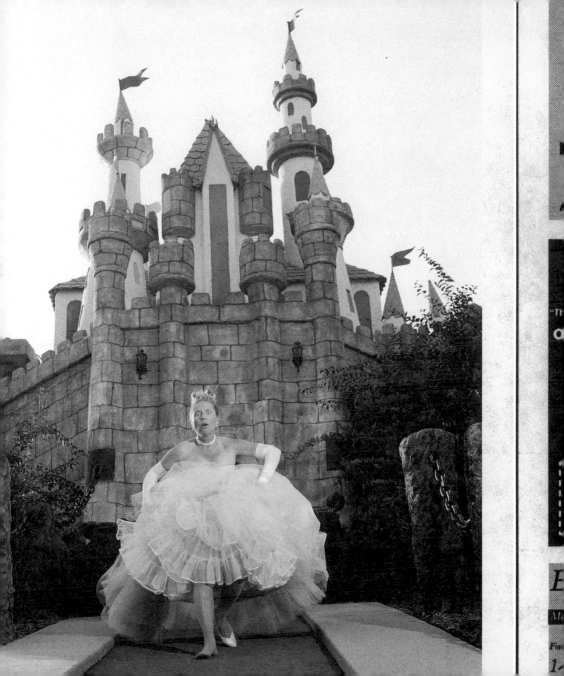

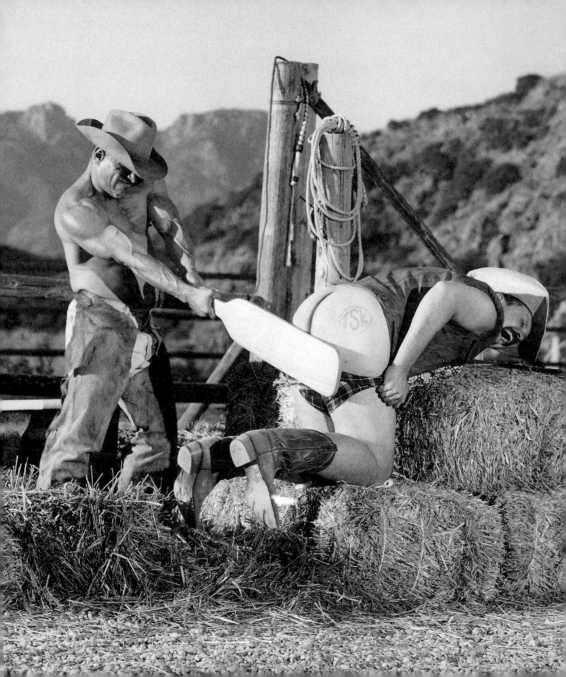

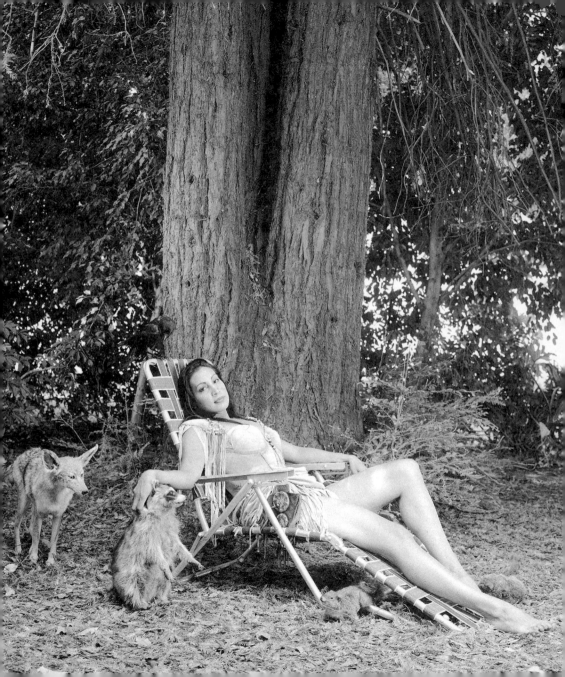

POCAHONTAS
SEEKS JOHN SMITH

Native American, 24, 5'11", raven eyes. Aries, digs industrial/gothic dance, seeks partner in crime. You: 24–30, Aquarius or Sag., tall, well-read, & like surprises. Call Box #48633. ☎

OUTERWEAR

L.A. GIRL SEEKS D.C. GUY

Conservative, romantic, SF, 29, attractive & intelligent, seeks SWM, 40–45 who's politically active (and a Democrat), into cigar clubs and rollerblading. Sophistication a must. Call Box #17584. ☎

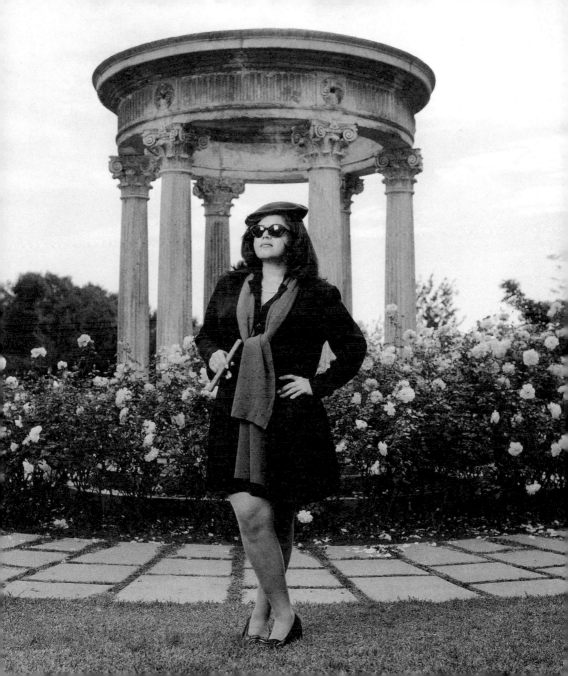

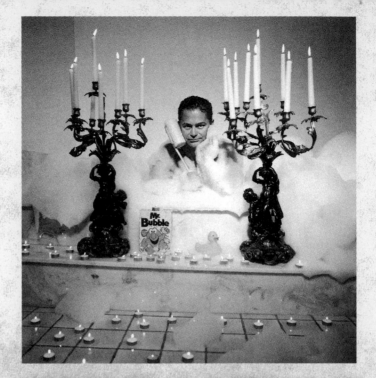

YOUR LOOFAH OR MINE

DWM, 41, concerned atheist, slightly husky build, clean shaven, my heart is the best ever in this strong mind & body. I love workouts, introspection, bicycling, cats, music, Venice, etc. Can I love you? Call Box #43587. ☎

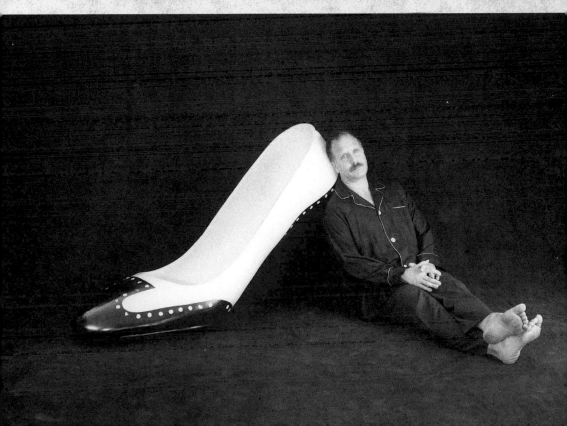

OKAY, SO I'VE GOT

slight foot fetish. Other than that, I'm a sane, intelligent guy seeking LTR. If we don't connect romantically, at least you'll get to go shoe shopping on my credit card. Call Box #76578. ☎

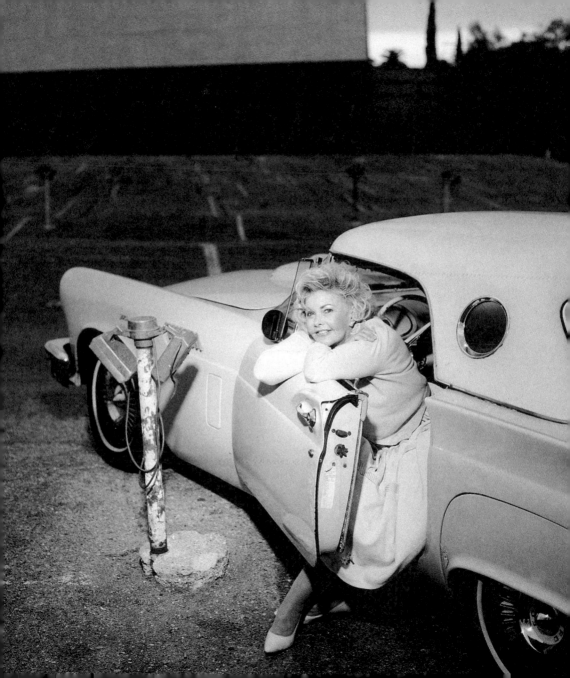

with a big car, hot body, and

SEXDAD

nasty abusive silver-topp

seeks submissive White/La

play. U must B cute shor

enjoy a mean dad. Serious

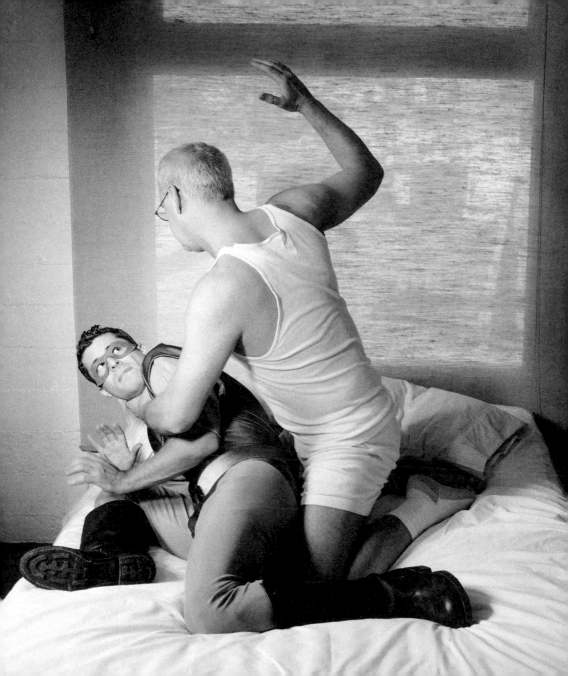

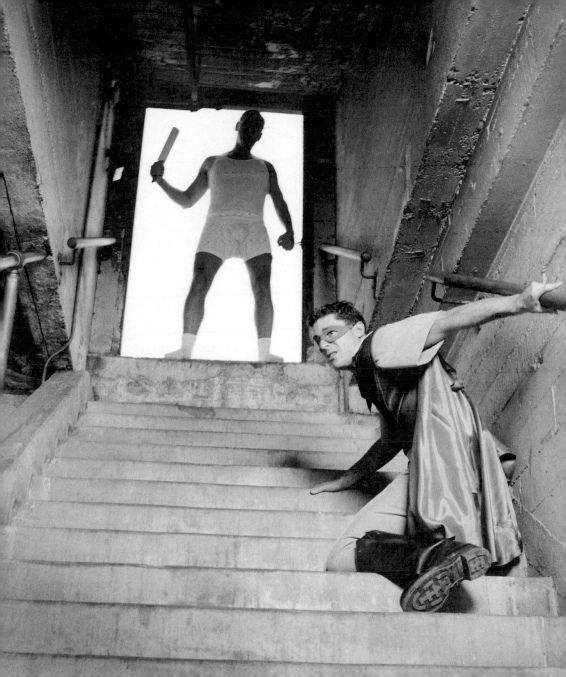

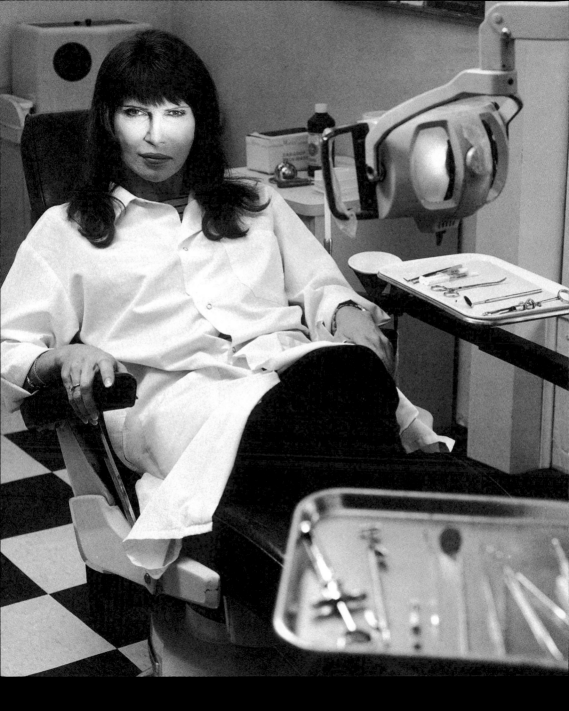

maintenance with high style. You must rise early and often. Call Box #26318. ☎

78-YEAR-OLD VIRGIN,

looking for same in a lady, 60–65, for dining out, travel, classical music concerts, long walks, & sightseeing. Call Box #63358. ☎

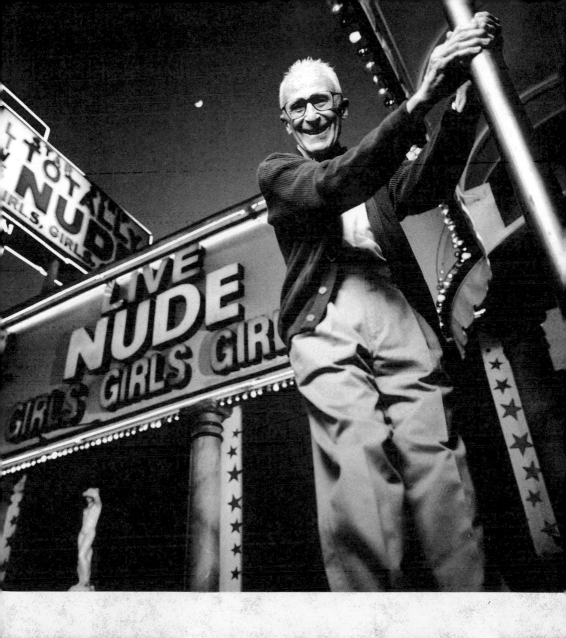

A NOTE ABOUT MICHAEL C. SMITH

by Patricia Garling

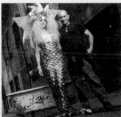 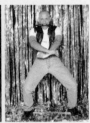

Before becoming a photographer, Michael Smith had led a career in advertising as senior vice president, Worldwide Creative, for Warner Bros. In earlier years he served as creative director at Chiat/Day, McCann-Erickson Worldwide, Revlon, Diane Von Furstenberg, *GQ* and *Esquire*. Named one of the "Ten Best Art Directors in America" by *Adweek*, Michael won numerous awards including the Bronze Lion from the Cannes International Film Festival and the Award of Excellence from the Advertising Club of New York. His photography, represented by galleries in Santa Monica, Sante Fe, and New York City, is in the collections of Elton John, Joel Silver, Herb Ritts, John Schlesinger, and Diane Von Furstenberg.

On July 21, 1999, Michael Smith passed away peacefully, in Santa Fe, New Mexico. It was most important to him that his first book, *Personals*, be published.

Always enthusiastic, always curious about life, and *always* smiling was Michael, my dear, sweet friend of twenty years. There is a song, "Secret o' Life" by James Taylor, that was a favorite of ours and that expresses his outlook well: "Since we're only here for a while / Might as well show some style / Give us a smile / Isn't it a lovely ride / The secret of life is enjoying the passage of time."

Michael was the ultimate best friend. He had a natural ability to make people feel at ease with themselves, to feel special and inspired. So, it wasn't surprising that he chose to photograph people who craved such rare recognition. Bringing to life the visionary fancy of each person's unfulfilled desire was an exciting creative challenge. In making *Personals*, he enjoyed the process as much as the outcome.

What did this book *really* mean to Michael? The best fantasies do indeed come true—if you have "the secret of life."

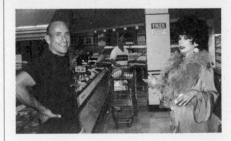

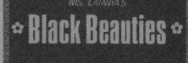